Po Po Says

Eight Inspiring Stories in
Asian American History

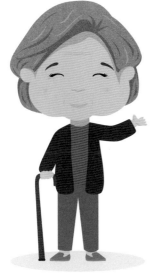

Written & Illustrated by **ASHLEY NG**

goff BOOKS

Over there is my grandma.

I call her "Po Po."

It means grandma in Cantonese.

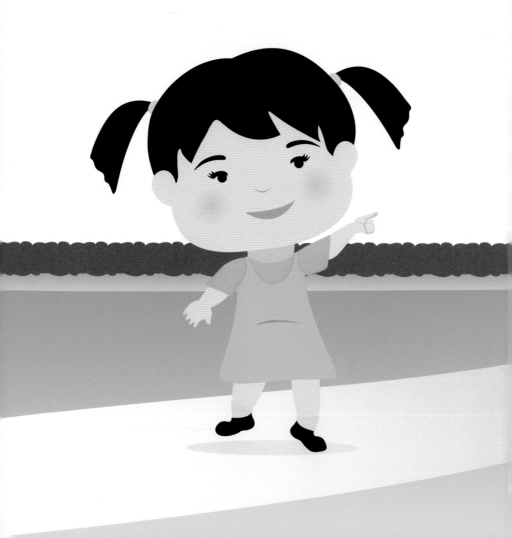

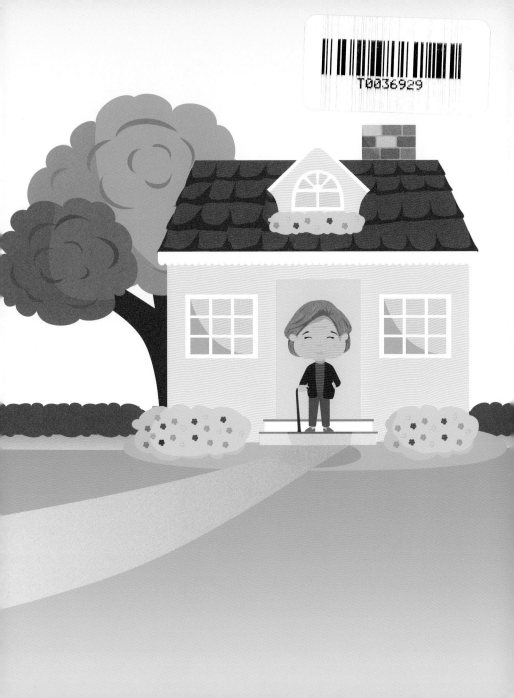

Every Sunday, I go to Po Po's home for lunch.
She cooks really good noodle soup. Yum!

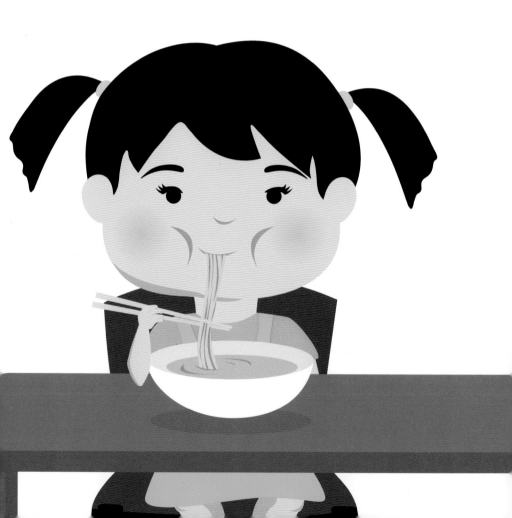

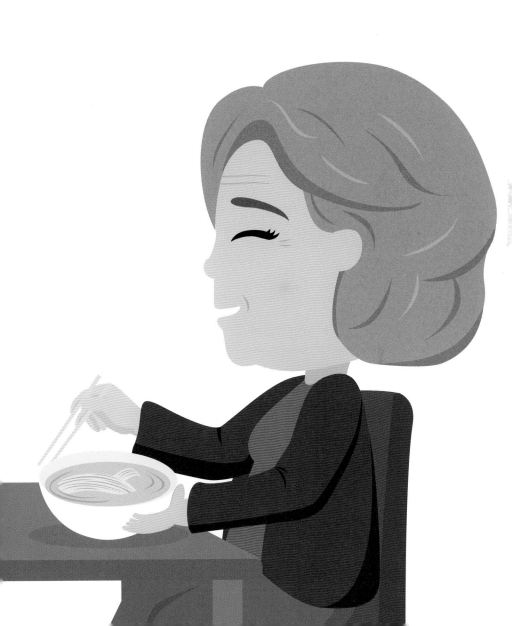

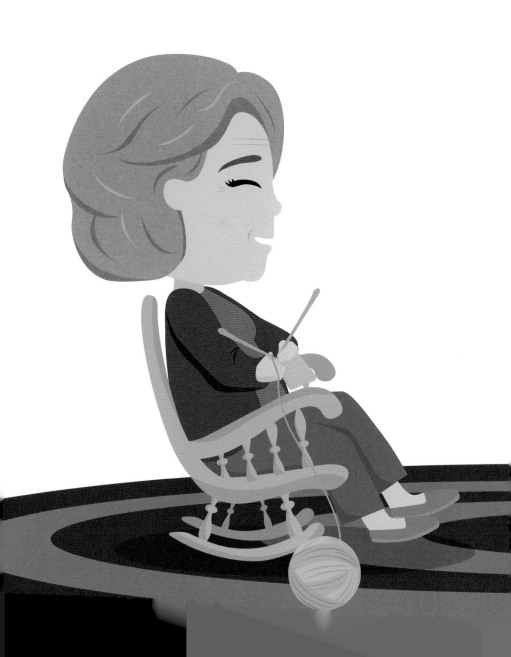

I love when Po Po knits while she talks.

Po Po says, "We must learn from our country's past.

Learn from the good and the bad.

Look forward and be the change that will last."

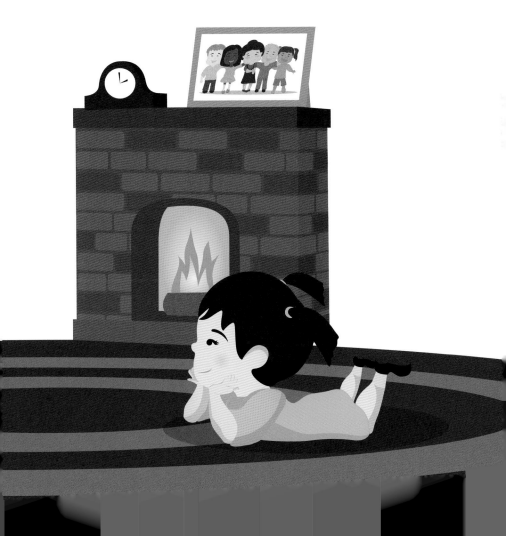

叻

(lek)

SMART

Po Po says, "Be smart like
the Manila Men."

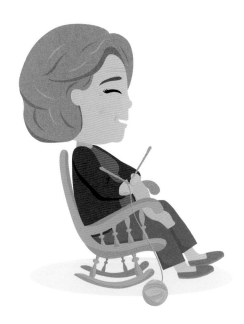

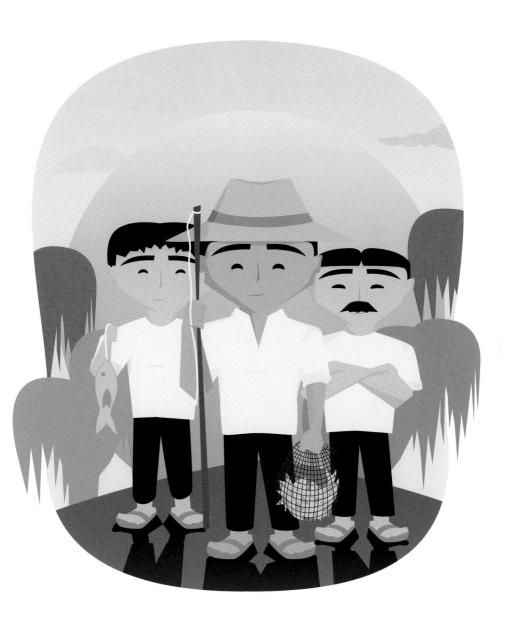

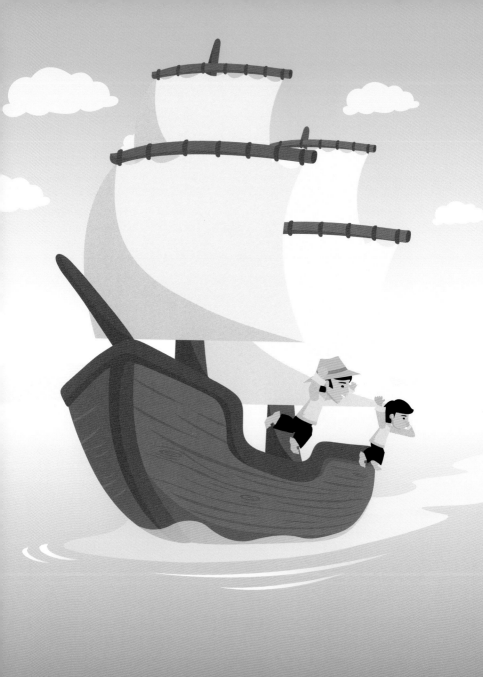

The Manila Men were Filipino
sailors on a big ship.
They helped bring goods
from the Philippines to
Mexico round trip.

One day they escaped from their
cruel captain and found their
way to the swamps of Louisiana.
Somewhere they could hide.
It was a new place to them, but
they had their smarts on their side.

They used what they knew.

They could build, they could fish,

and made a life that grew.

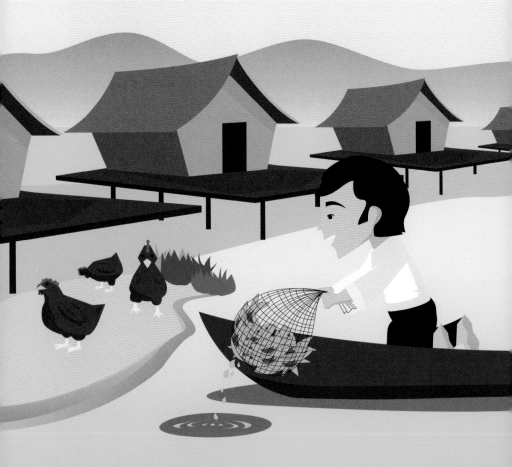

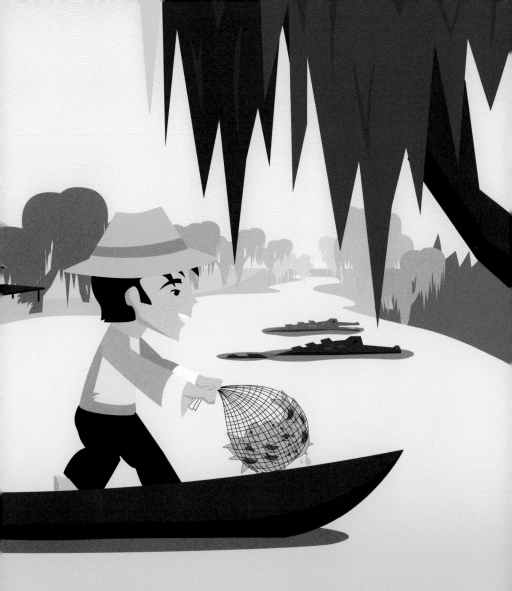

They used their skills and worked in unity.

They are known to be the first Asian American community.

決心

(kyut-sum)

DETERMINED

Po Po says, "Be determined like the Chinese immigrants of the Gold Rush."

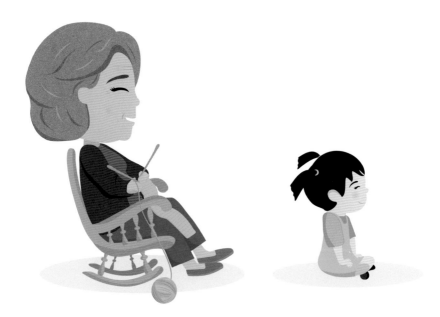

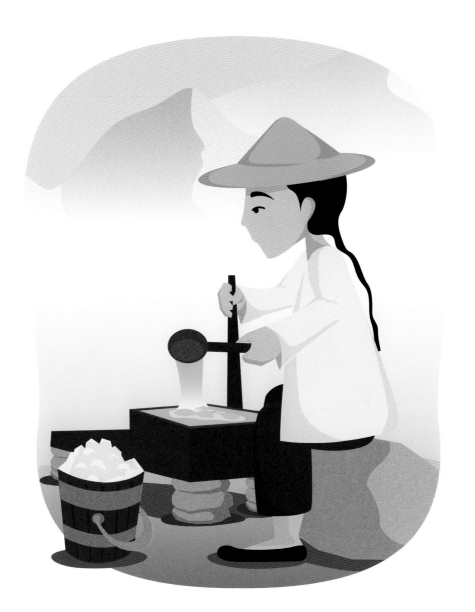

Thousands of people from
all over the world traveled to
California in search of gold.
A life of riches they were told.

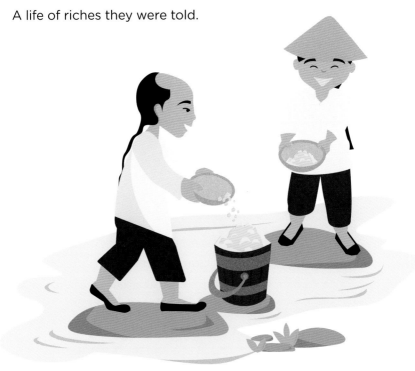

Many of those people were
Chinese immigrants.
But other people did not like
that they were different.

Other gold miners were mean to the Chinese because they did not like how they looked. They tried to scare them away and told them, "That's my gold you took."

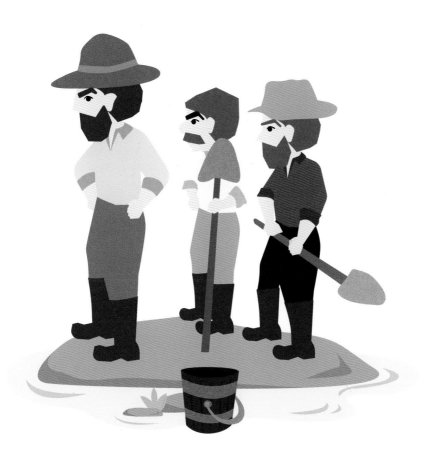

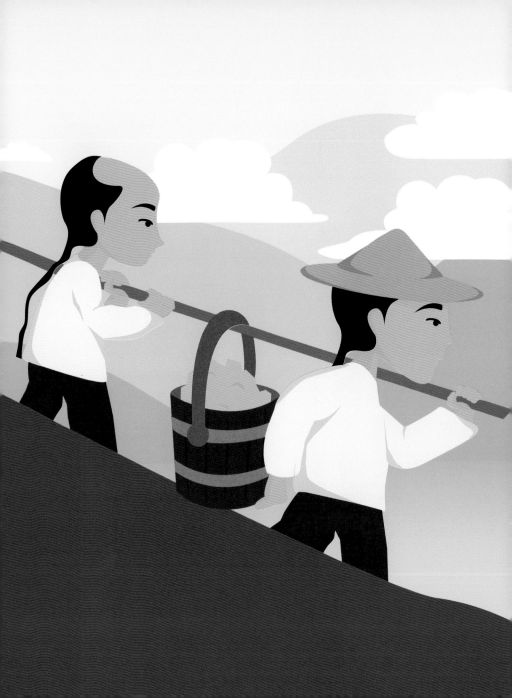

But they were determined to build better lives for their families. They remained bold and continued to mine for gold.

Some even opened up their own businesses in restaurants, laundry, and stores. This led to opening new doors.

堅强

(gnai-lick)

PERSISTENT

Po Po says, "Be persistent like the Chinese railroad workers."

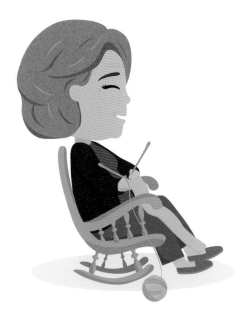

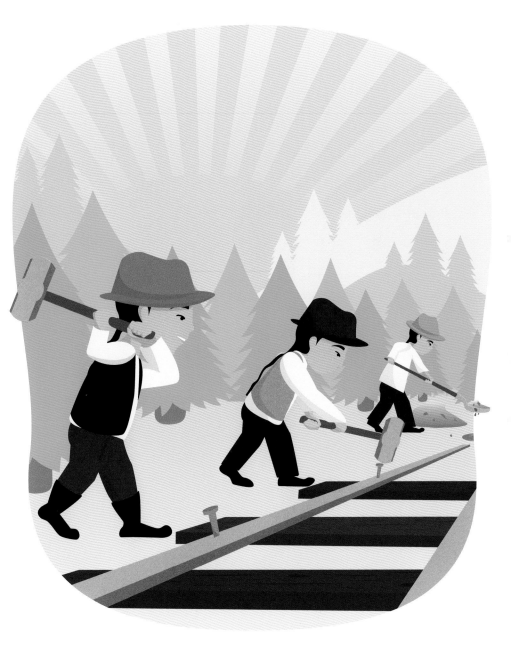

The first railroad across the U.S.
was built by Chinese workers.
They showed people that they
were strong, fearless, and fast.

It was dangerous work and
there were holes in mountains
that they would blast.

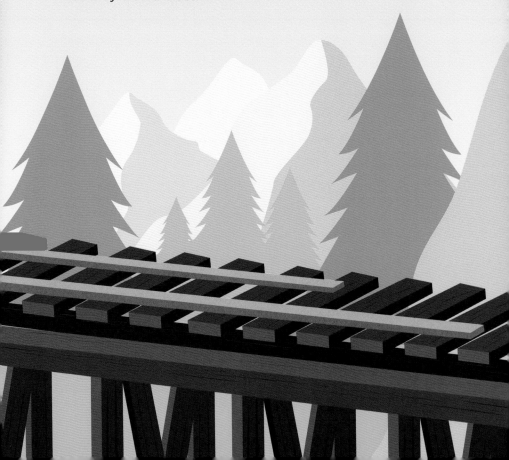

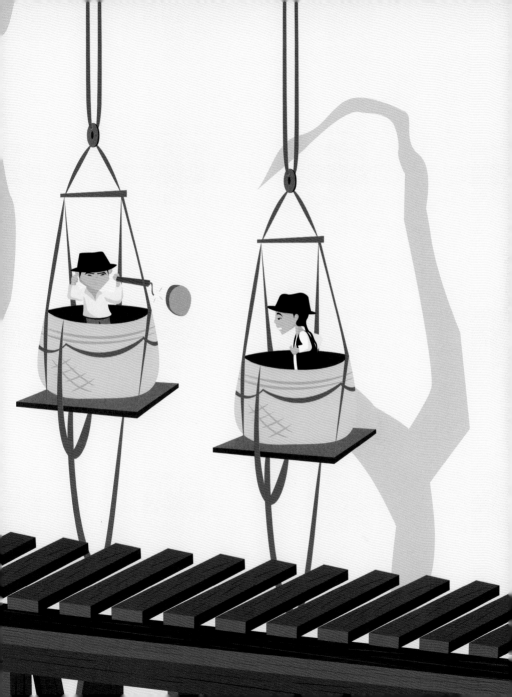

Even through the danger, they were persistent.
Without their hard work, the Transcontinental
Railroad would be non-existent.

They united our country from the East to West
Coast. Their hard work is something we should
honor and boast of.

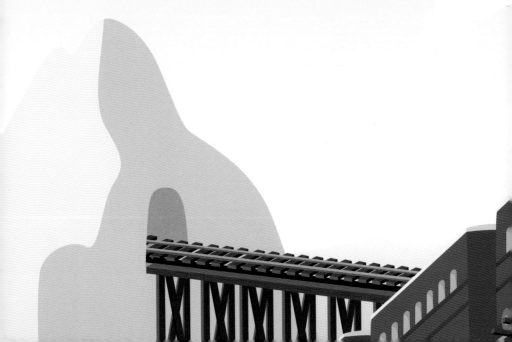

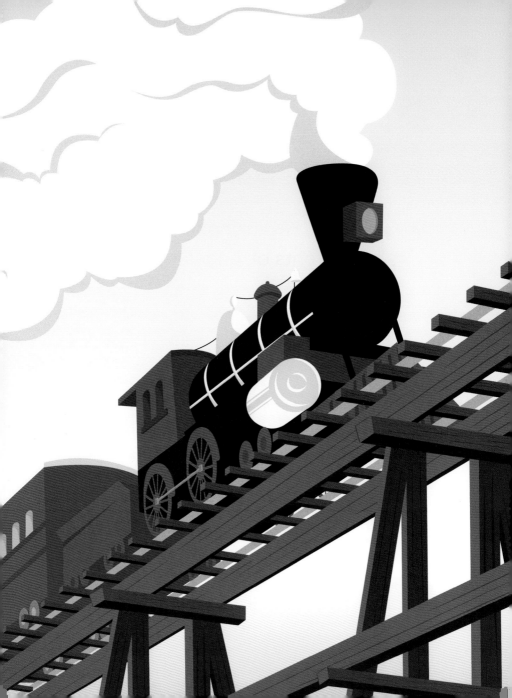

勁

(ging)

STRONG

Po Po says, "Be strong like the Asian immigrants of Angel Island."

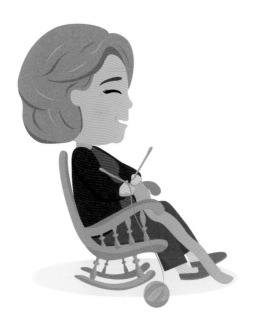

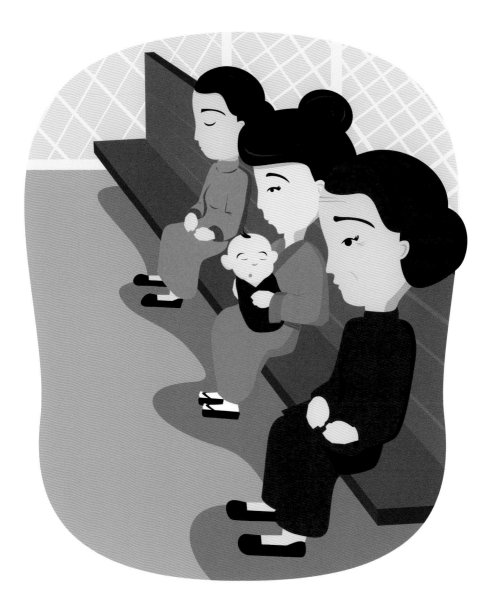

Thousands of Asian immigrants
were forced to wait on Angel Island.

Locked up inside small wooden
buildings. They were angry, worried,
and full of fears.

To enter the U.S., they had to wait days,
months, and some even years.

山野原來是監，
埃崙此地爲仙島，

Many transformed their feelings into songs of poetry. They carved these words into the soft wooden walls that confined them.

Their writings still echo their fears, frustrations, and hopes of what could be left behind 'em.

The American dream and
freedom was in sight.
And that's all the more reason
they continued to fight.

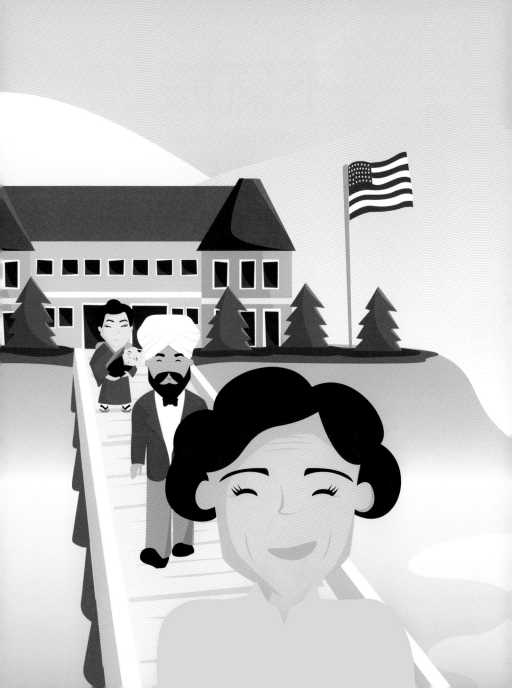

不氣餒

(bat hey lui)

RELENTLESS

Po Po says, "Be relentless like
the detainees of the Japanese
internment camps."

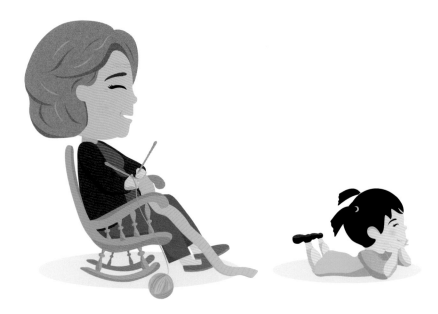

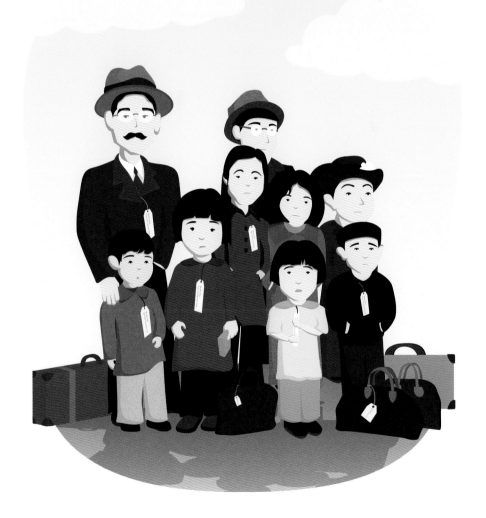

During World War II, thousands of Americans were forced to leave their homes because of their Japanese descent.

This was not fair because Japanese Americans are American, one hundred percent.

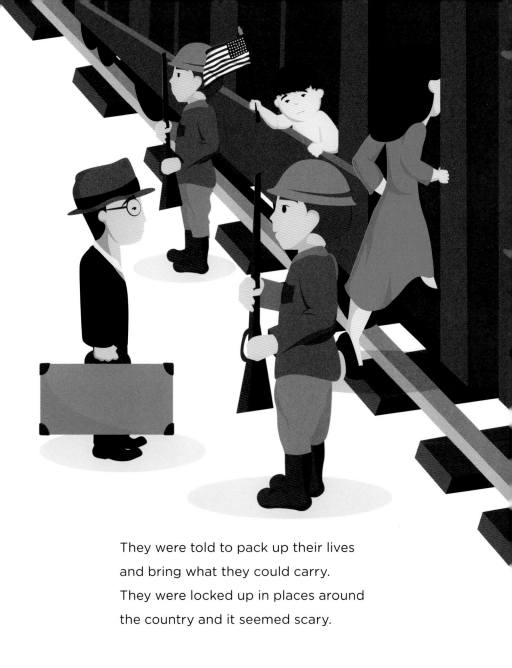

They were told to pack up their lives
and bring what they could carry.
They were locked up in places around
the country and it seemed scary.

These places were called internment camps.
Unlike summer camps, these places were not fun.
They had barbed wire fences and soldiers with guns.

But the Japanese Americans were relentless.
They knew they could survive.
They worked together to create schools, farms,
and made a life where they could still thrive.

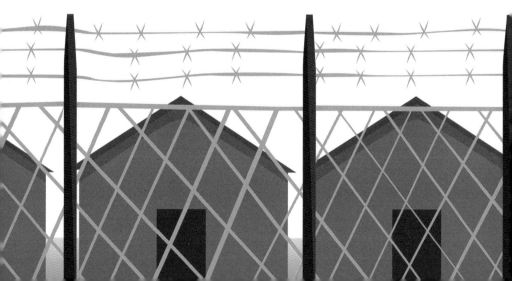

After three long years the war was over. Japanese Americans were told they could return to their lives, but their lives looked much different than before.

Their homes and businesses weren't there anymore.

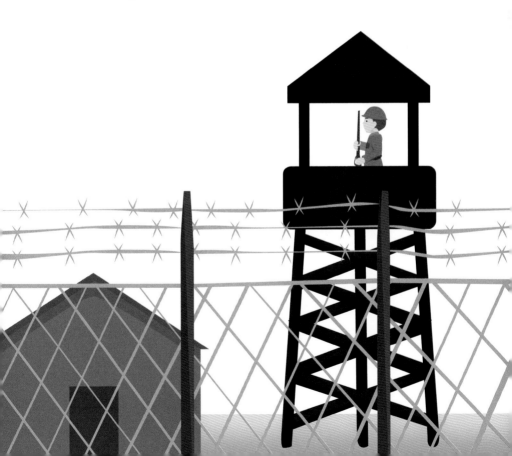

But the Japanese Americans
were relentless. They rebuilt
their lives and worked harder
than ever.

A moment in history we will
remember forever.

(jung)

BRAVE

Po Po says, "Be brave like the Nisei soldiers of World War II."

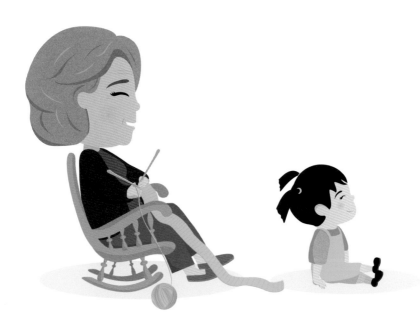

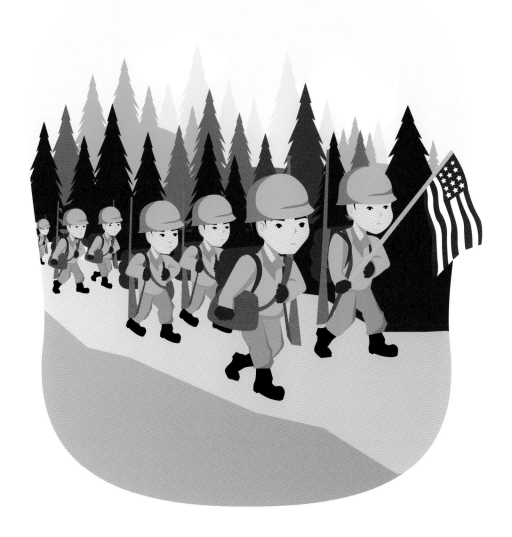

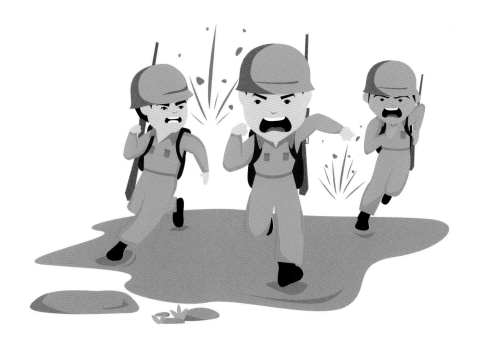

Nisei Soldiers gave courage and strength.

They were second generation Japanese Americans
that fought for the U.S. at great length.

Even when the nation forced them into internment
camps, they signed up to help their country in battle.

They were known as the 442nd Regiment.
They were strong, fearless, and intelligent.

They yelled, "Go for broke!" to ignite the energy they wanted to invoke.

Their courage and fighting spirit helped lead to the country's victory.

They earned the most medals for a U.S. military unit of its size. And that's something we should all recognize.

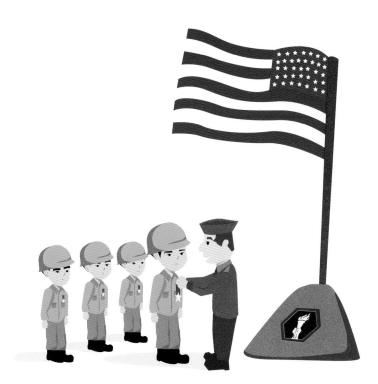

靭

(cha)

RESILIENT

Po Po says, "Be resilient like the Vietnamese Boat People."

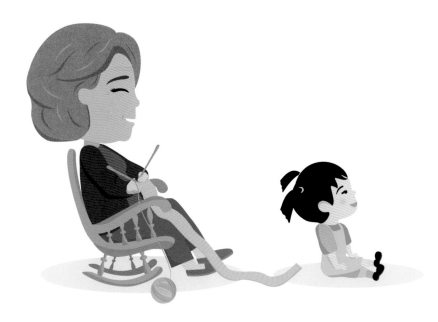

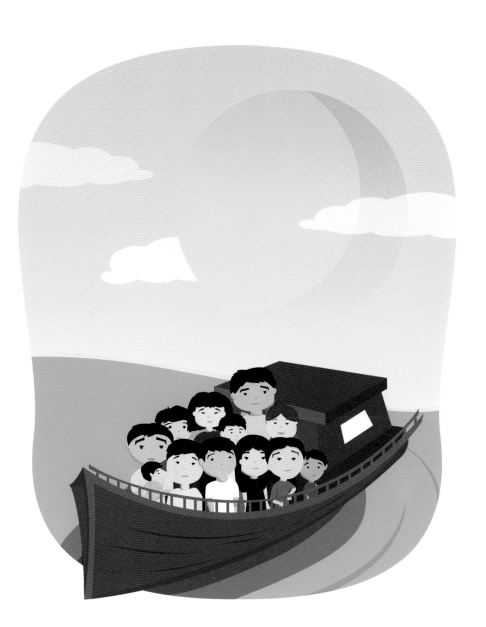

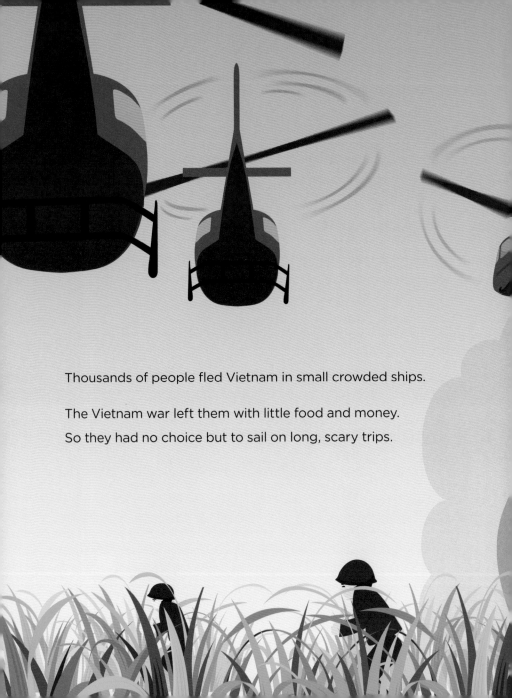

Thousands of people fled Vietnam in small crowded ships.

The Vietnam war left them with little food and money.
So they had no choice but to sail on long, scary trips.

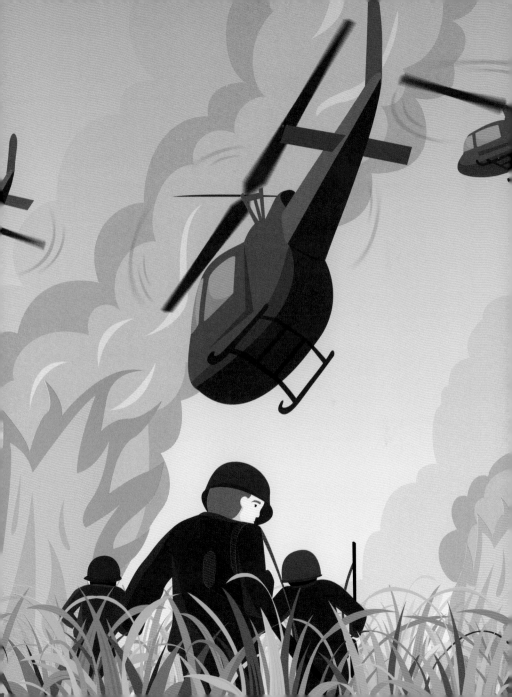

They were known as Vietnamese Boat People because in boats they would flee.

Their ocean journey was very dangerous because of big waves and pirates at sea. But they were resilient and had a will to survive.

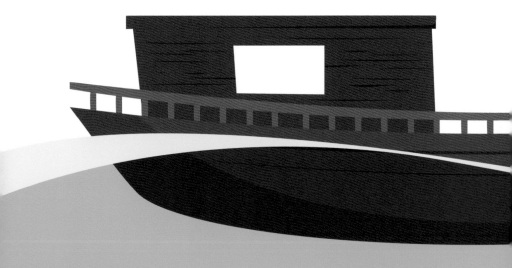

They thought of their families and their hopes of building better lives.

They found people who could help them to safely reach the U.S. Their strength and dreams pushed many of them to success.

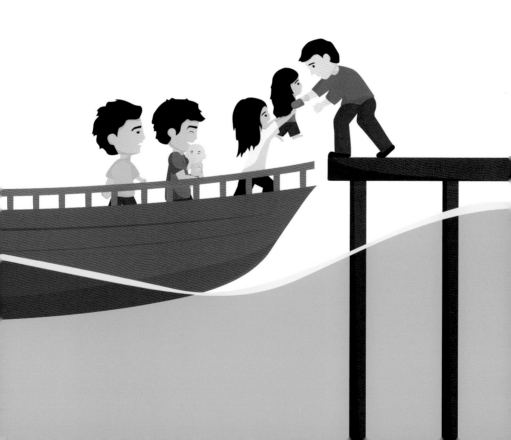

說出

(syut-chut)

VOCAL

Po Po says, "Be vocal like the students who saw the need for ethnic studies."

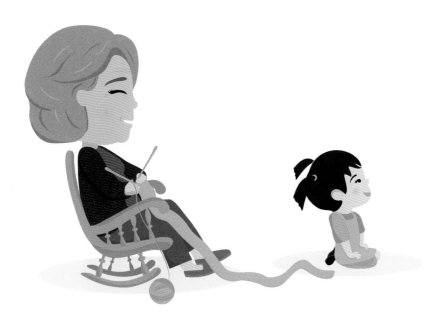

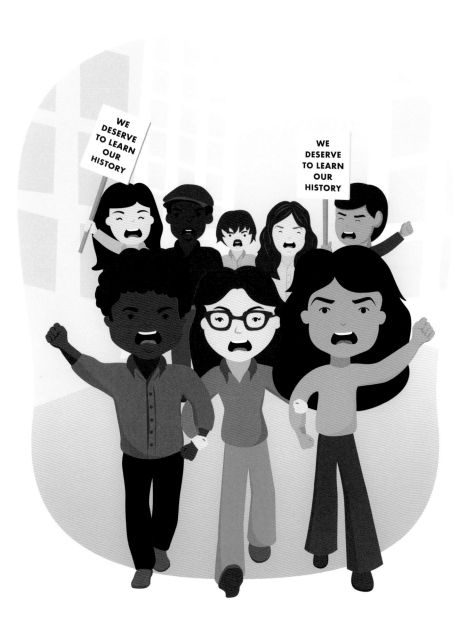

College students called for their schools to include the stories of all Americans who make up our beautiful nation.

They came together to protest and tell them that there needs to be better representation.

They spoke up and used their voice.
Now, many can study ethnic studies as a choice.

That means we can learn our own history and
embrace all the cultures that make up the U.S.
This was a step towards progress.

For hundreds of years, different people have come from all over the world. We can learn from the past and make a change that will last.

Po Po says, "Just like this scarf, we are all tightly knit."

She wraps it around me and says to take a look at it.

Po Po says, "Each loop of yarn represents a different person. And together, we create something strong and beautiful."

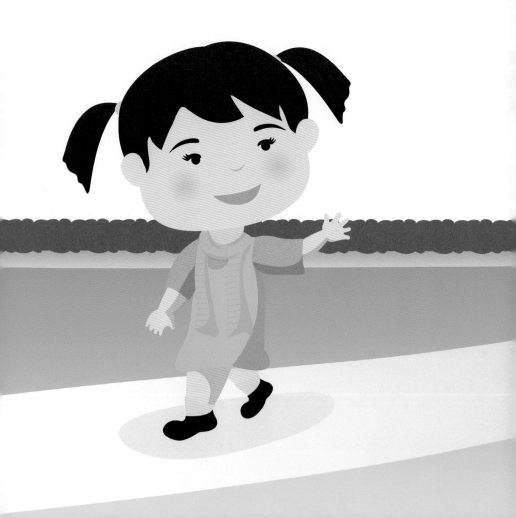

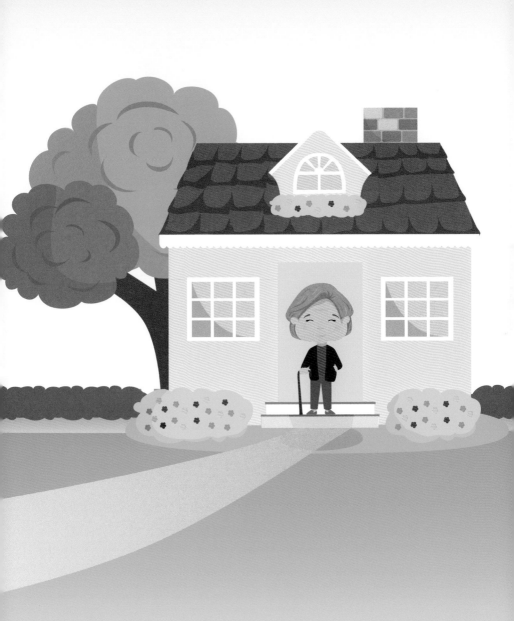

For Po Po and Mom, who taught me to be strong,
determined, and so much more.

—A.N.

Published by Goff Books, an Imprint of ORO Editions.
Executive publisher: Gordon Goff.

www.goffbooks.com
info@goffbooks.com

USA, EUROPE, ASIA, MIDDLE EAST, SOUTH AMERICA

Author & Book Design: Ashley Ng
Project Coordinator: Alejandro Guzman-Avila
Managing Editor: Jake Anderson

10 9 8 7 6 5 4 3 2 1 First Edition

Library of Congress data available upon request. World Rights: available.

ISBN: 978-1-935935-53-7

Color separations and printing: ORO Group Ltd.
Printed in China.

International distribution: www.goffbooks.com/distribution

ORO Editions makes a continuous effort to minimize the overall carbon footprint of its publications. As part
of this goal, ORO Editions, in association with Global ReLeaf, arranges to plant trees to replace those used
in the manufacturing of the paper produced for its books. Global ReLeaf is an international campaign run by
American Forests, one of the world's oldest nonprofit conservation organizations. Global ReLeaf is American
Forests' education and action program that helps individuals, organizations, agencies, and corporations
improve the local and global environment by planting and caring for trees.